Wally Gilbert

Black & White

Copyright Notice: Copyright ©2013 by Wally Gilbert

An Exhibition

at

KHAKI GALLERY
April 1st – July 31st, 2013

460 Harrison Avenue
Boston, MA 02118

Khaki Gallery Boston is pleased to present "Black & White," new photographic works by Wally Gilbert, a Nobel Prize-winning molecular biologist turned visual artist. In this latest series, Gilbert explores the effects of opposite extremes in the most minimal of colors, black and white.

Gilbert's latest work plays with the effects of monochromatic light, surprising us by their daring combination of modernity with the spiritual. The work featured in this exhibition ranges from images taken from the artist's travels, including "Roof – Tuscany" and "Chimneys #2" as well as striking abstractions created by overlapping images in the computer, including "Lights Symmetric" and "Try this". "I have begun to explore black and white images, where the whole feeling is in shapes and the effects of light. While most of these are pure photographic images, converted to a grayscale continuum, some of the images are solarized in the computer, to produce overlapping structures in both negative and positive space." said Gilbert. Some of these images are printed directly on aluminum metal sheets, which further emphasizes the contrast between light and dark.

Gilbert had a long international career as a scientist, winning a Nobel Prize in 1980 for his landmark work in discovering a rapid DNA gene sequencing method. As an artist, Gilbert reveals to us a world that could be invisible to the ordinary eye. "I create photographic images of fragments of scenes, working on a border between visual reality and emotional abstraction, exploring pattern, color, form, and texture."

Nahid Khaki Boston, MA

Catalogue of Images

Italian Floor #1	11
Lights – Boston	13
Water Towers – New York, Black and White #1	15
Lights Symmetric #3	17
Try This	19
Tiles #2	21
Chimneys #1 – Boston	23
Many Flying, #2	25
Floor – Italy, Black and White #1	27
Floor – Italy, Black and White #2	29
Roof – Tuscany	31

Italian Floor #1

2012

30" x 20"

Printed on Aluminum

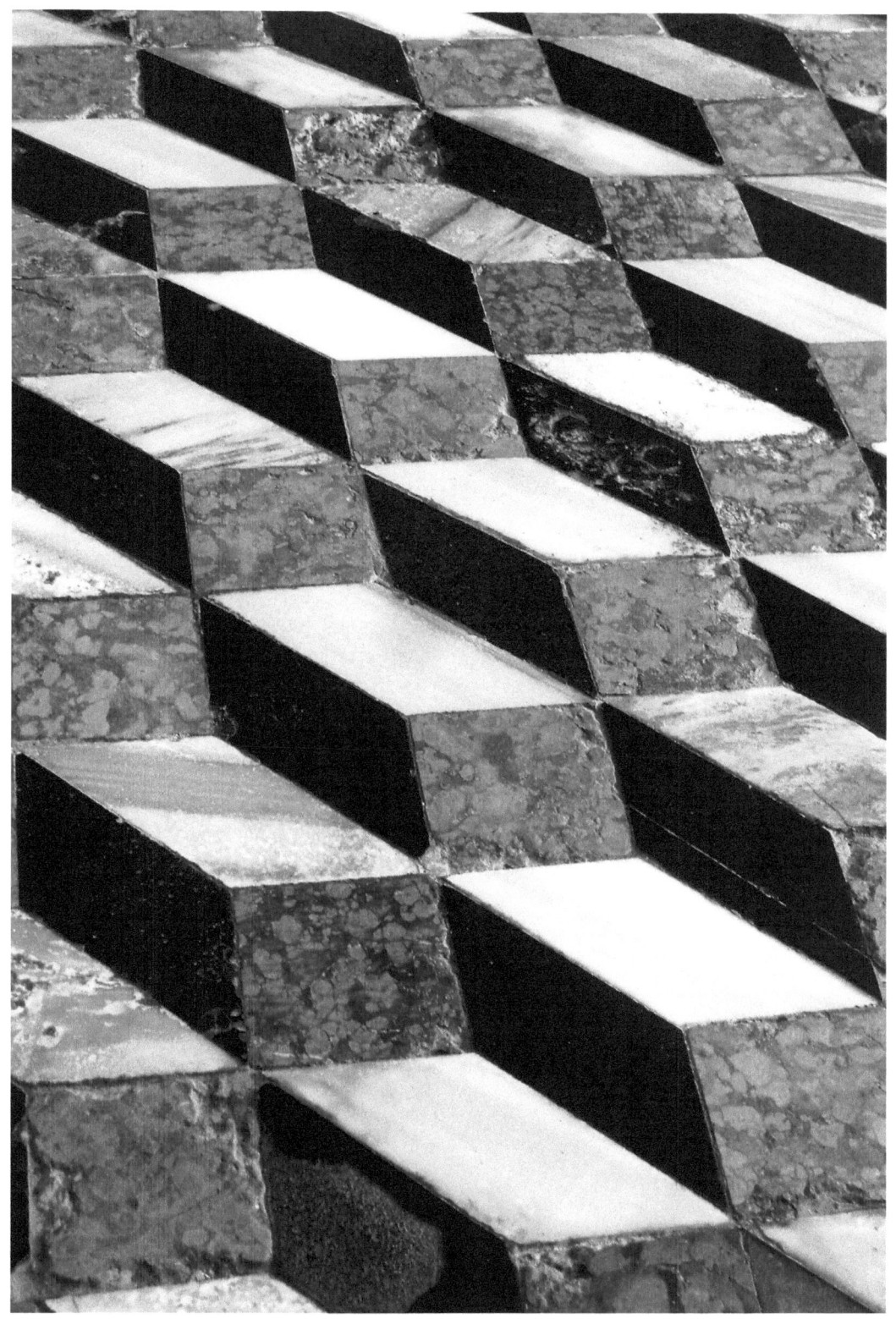

Lights – Boston

2013

30" x 20"

Printed on Aluminum

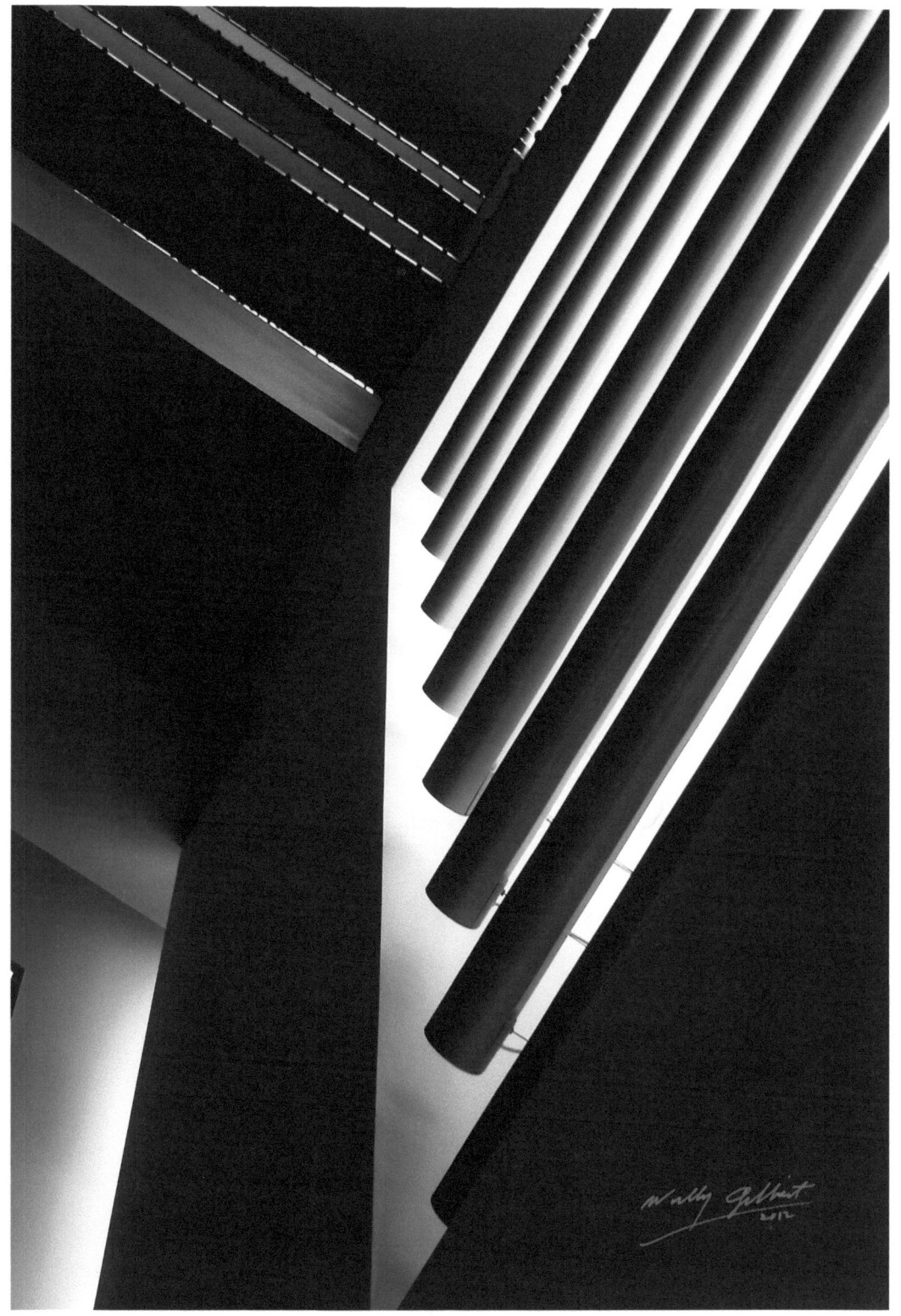

Water Towers – New York, Black and White #1

2012

30" x 20"

Printed on Aluminum

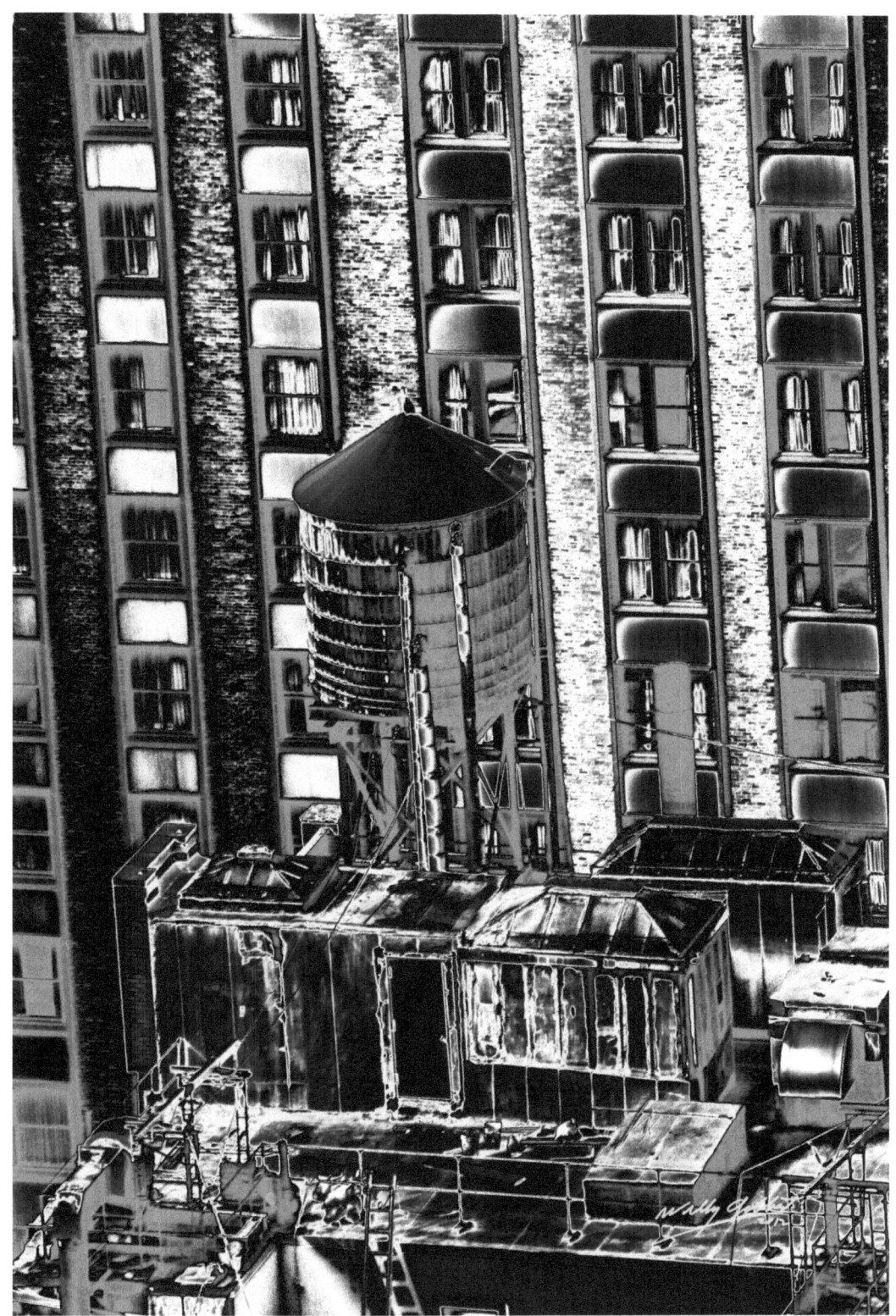

Lights Symmetric #3

2012

30" x 20"

Printed on Aluminum

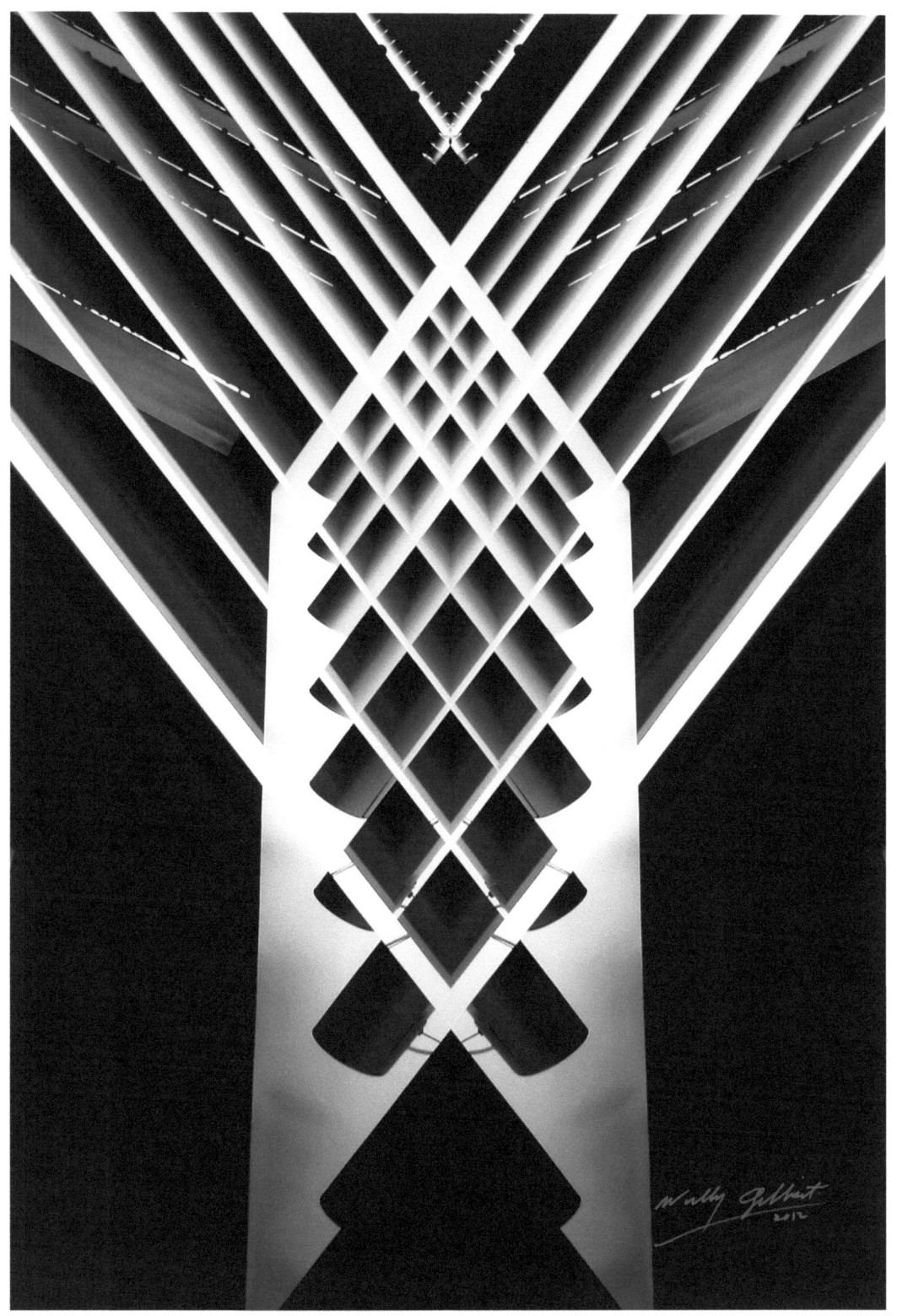

Try This

2012

30" x 20"

Printed on Aluminum

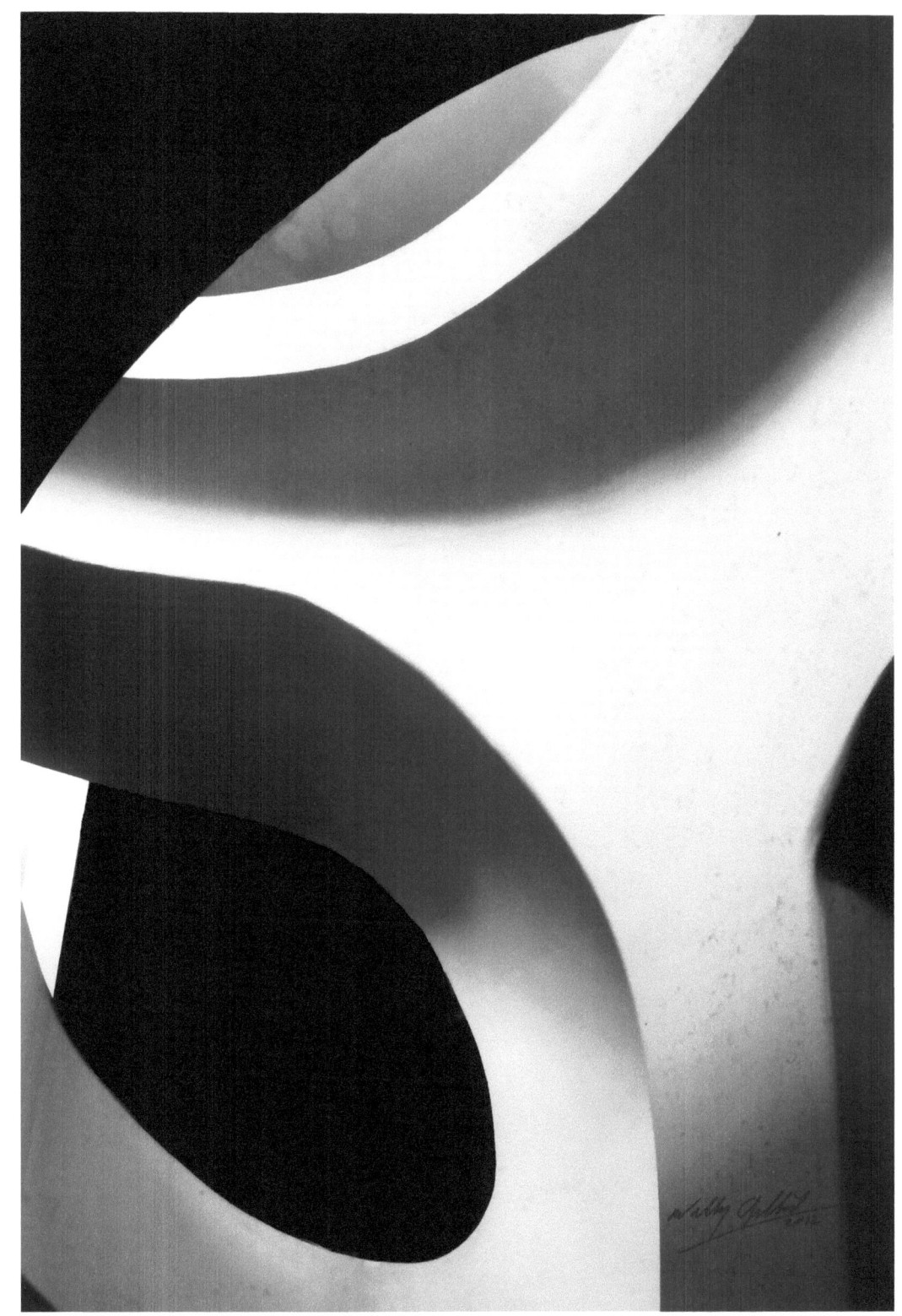

Tiles #2

2012

30" x 20"

Printed on Aluminum

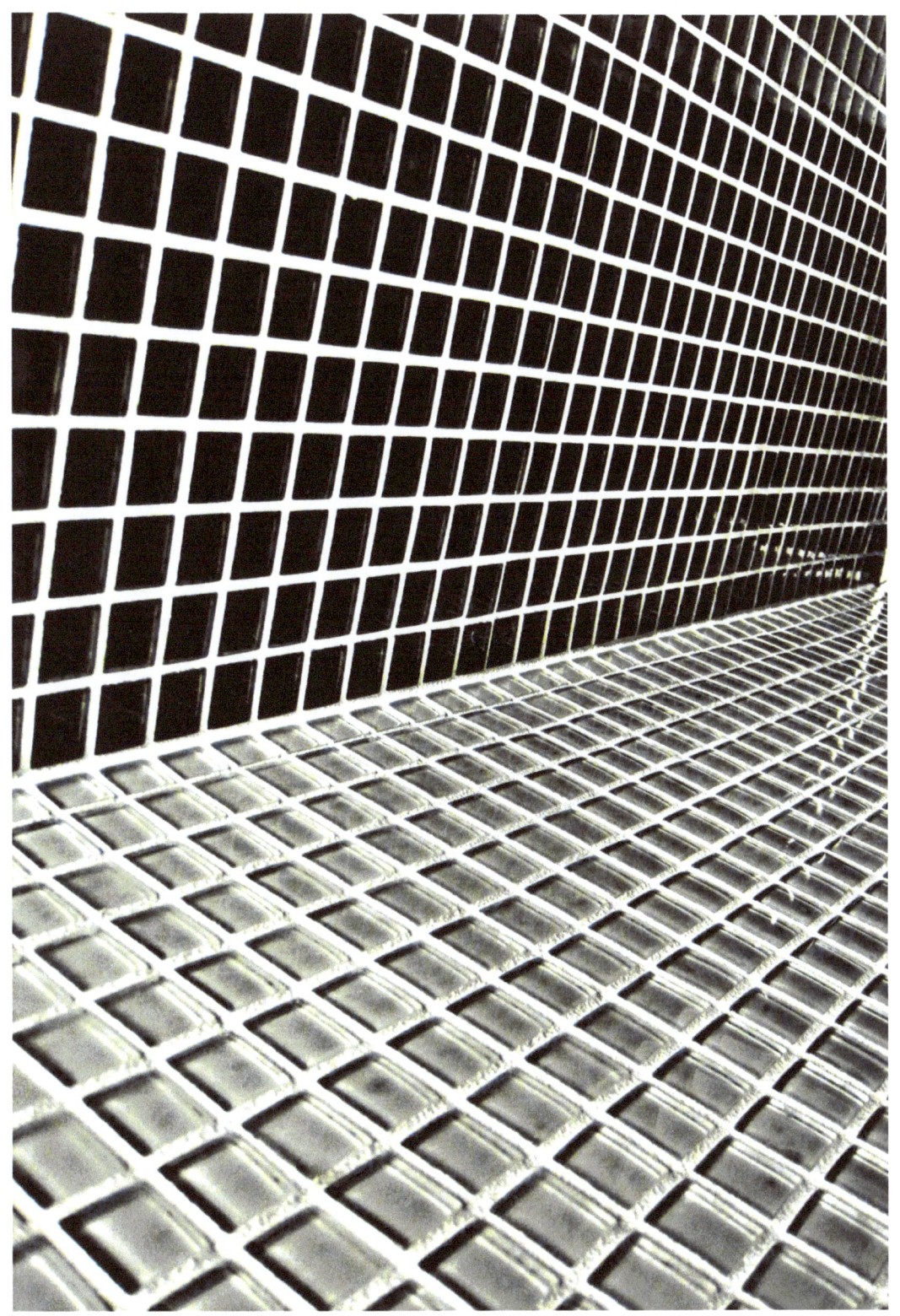

Chimneys #1 – Boston

2012

30" x 20"

Printed on Aluminum

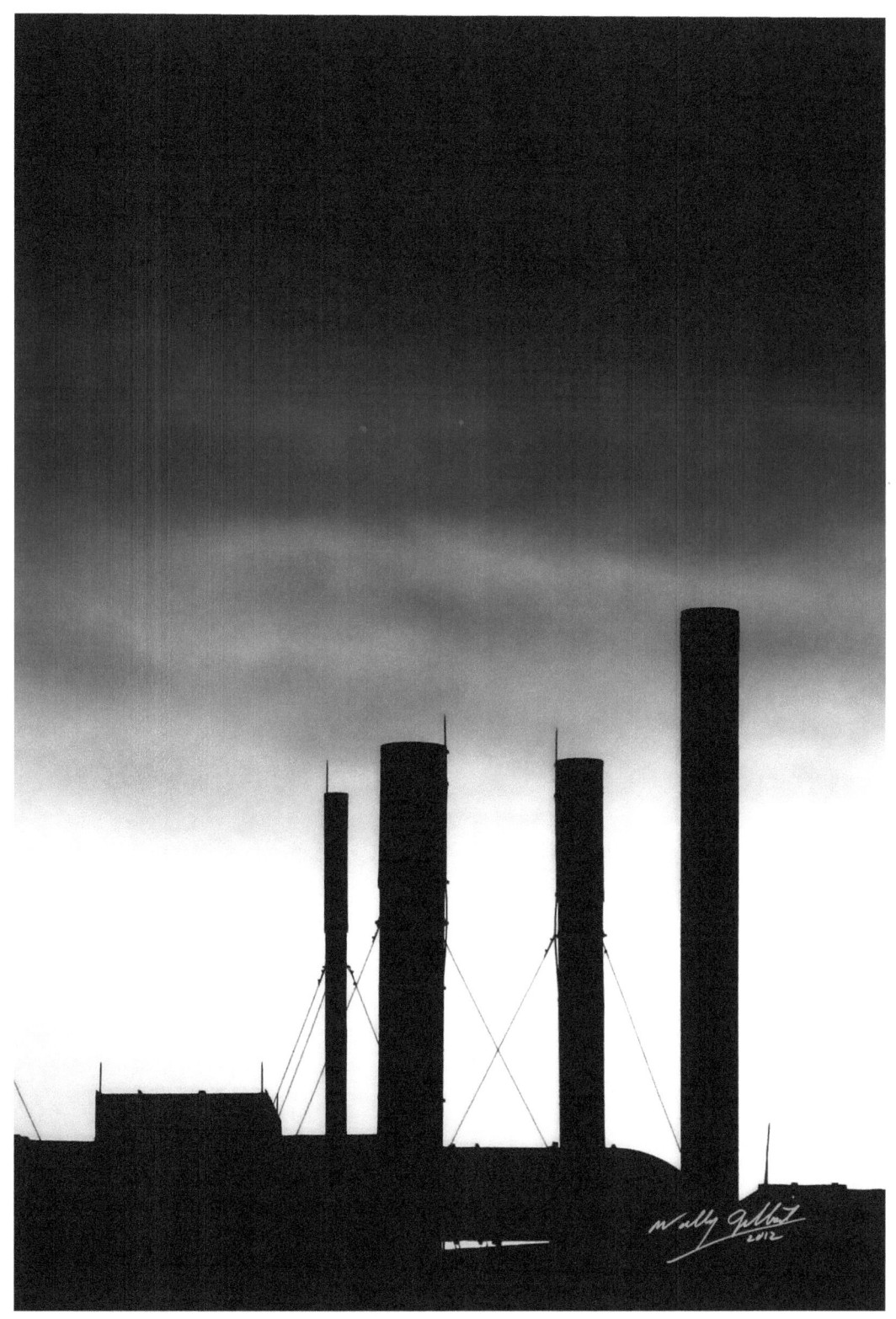

Many Flying, #2

2013

40" x 60"

Kodak Print mounted on Ultraboard

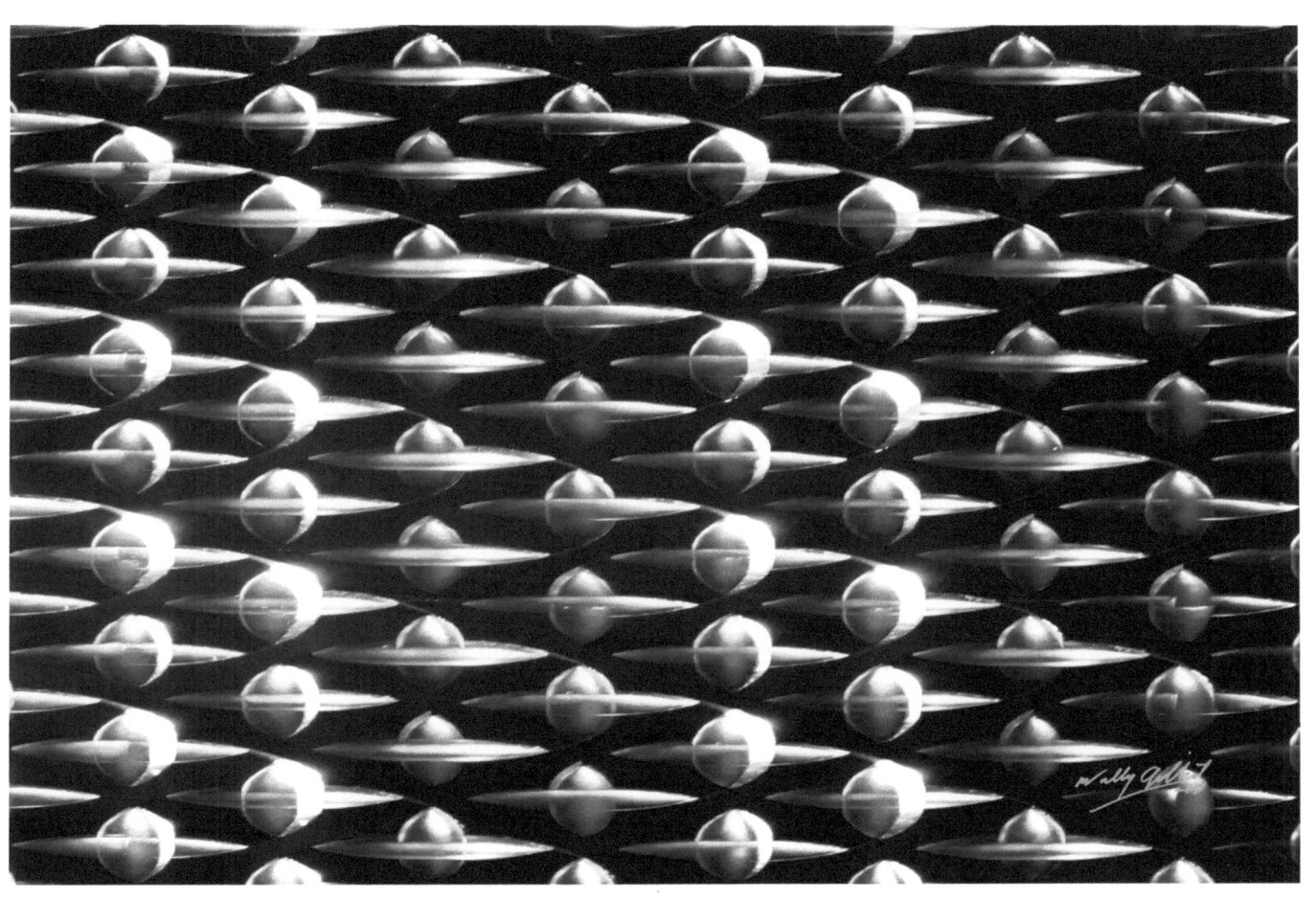

Floor – Italy, Black and White #1

2013

40" x 60"

Kodak Print mounted on Ultraboard

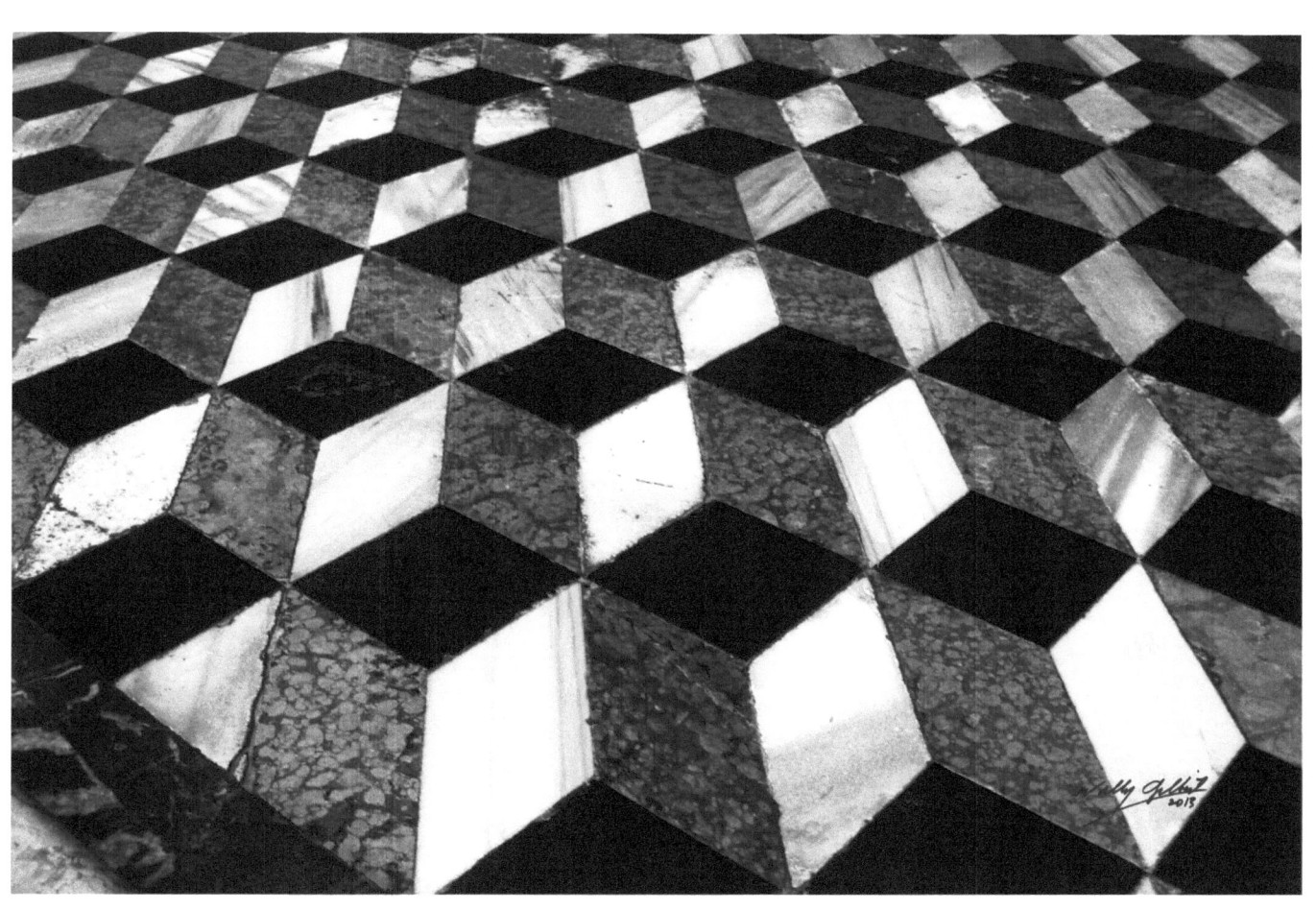

Floor – Italy, Black and White #2

2013

40" x 60"

Kodak Print mounted on Ultraboard

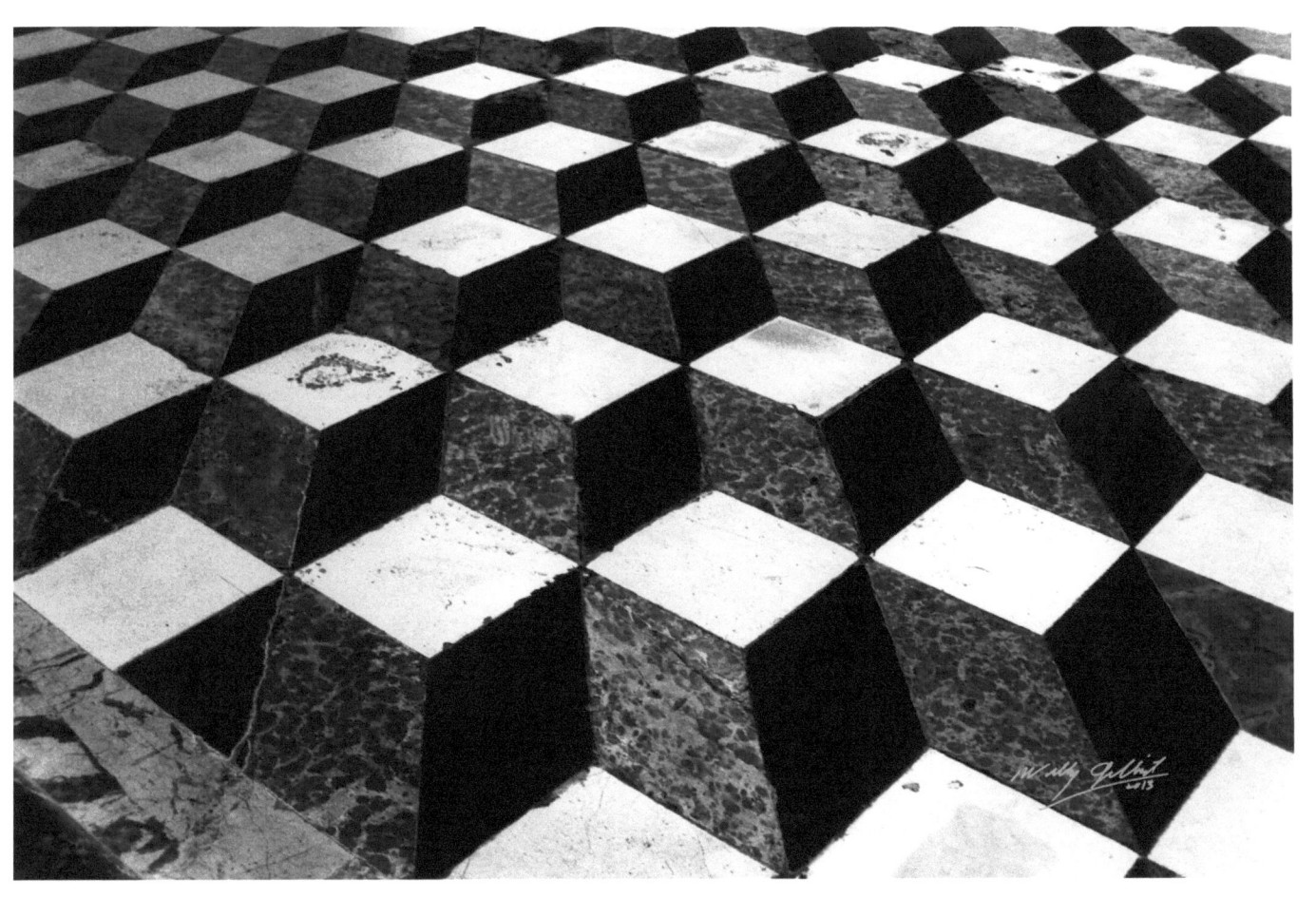

Roof – Tuscany

2012

40" x 60"

Kodak Print mounted on Ultraboard

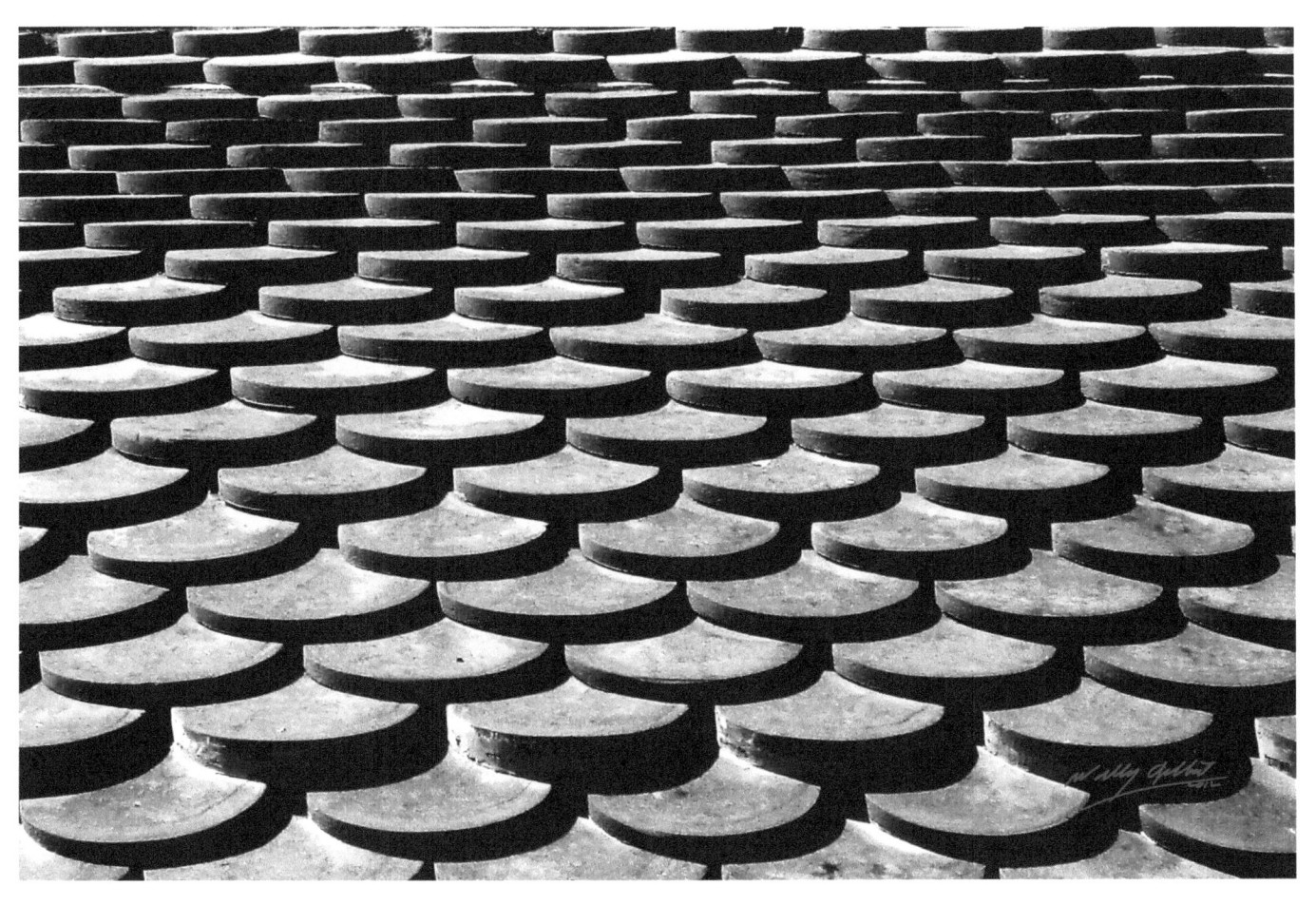

Artist's Statement

I began making digital images as art when I discovered that I could make large prints from images taken with a small digital camera and that these prints carried an emotional and asthetic impact. My earliest work was of fragments of the visual world, either portions of natural scenes or of man's architectural or industrial artifacts. My first one-person show included a 48" x 72" image made from a two mega-pixel camera.

I was invited to Poland, to do an installation at the Norblin Site in Warsaw, by Jan Kubasiewicz and Josef Piwkowski. These photographs of decaying machinery were installed in Warsaw in the Summer of 2007 as twenty-six 12' x 8' hangings and thirty 36" x 24" prints, face-mounted on plexiglas. This show was exhibited again in Lodz and in Poznan.

After photographing dancers in the ballet, I went on to explore abstractions, first in a "Vanishing" series, that was based on a natural form, the outline of a human head. The many patterns produced in that series all shared some aspect of a biological or natural curve, which still was manifest even in the smallest cropping of those images.

In my later work the basic element is a straight, shaded line, which I used to create geometric patterns. The "Geometric Series" explored patterns in color or black-and-white created from overlapping squares or triangles or just from lines, taken either simply or in intersecting groups.

I make many images by hand on the computer. The computer simply holds the intermediate forms as I superpose the many layers I create to build up the image. The images begin in black and white, and then I color them in the computer. I generate these colors either by accessing the colors available or, in a more complicated fashion, by using the ability to change the global input-output functions for each color and intensity separately. When the layers containing the colored images interact with each other, still more color patterns appear. The computer is a digital workspace, driven by my hand and eye.

My most recent work lies in two opposing directions. One involves photographs moved to extreme values in color space yielding strange color contrasts, while the other direction, as seen in this show, is rigorousy monochromatic, a restriction, again unnatural, to black and white.

These images exemplify my delight in light and form, and my search for a three-dimensional effect on a two-dimensional surface. I search for depth beyond the picture plane and for mystery.

Wally Gilbert's Biography

Wally Gilbert had a long international career as a scientist, working in Molecular Biology on genes and DNA. He was awarded a Nobel Prize in Chemistry, in 1980, for solving the mystery of DNA sequencing. Fred Sanger in England and Gilbert in the United States shared that prize for finding ways to decipher the order of chemical groups along the DNA molecule and hence to make it possible for the first time to read the genes. Those discoveries drove the development of Biology as a gene-based science across the last three decades and led to the working out of the Human Genome program and the current understanding of all organisms.

For the last ten years Gilbert has been working in Digital Art. He began by making large images of fragments of the world, focusing on form, texture, and color, using a small digital camera. Very often these pictures were drawn from machines or from architecture. Jan Kubasiewicz, a professor at the Massachusetts College of Art, saw his work and organized his first one-person exhibition in 2004. He was invited to Poland, by Kubasiewicz and Jozef Zuk Piwkowski, to create an installation at the Norblin Site in Warsaw, an old decaying factory. This installation, consisting of twenty-six 12' by 8' hangings and thirty 36" x 24" prints face-mounted on Plexiglas, was installed at Norblin in Warsaw for two months in 2007 and then later that year in Łodz and again in Poznan in 2009. The set of thirty face-mounted prints were also exhibited in New York, Washington D.C., Los Angeles, and San Diego.

Gilbert was invited to participate in creating a book on the Boston Ballet Company. He spent several years photographing ballet dancers in rehearsal. These pictures, which capture the joy and motion of the dancers, appeared in a book on that company "Behind the Scenes at Boston Ballet" by Christine Temin with 68 pictures by Wally Gilbert.

Gilbert then moved to abstractions, first based on silhouettes derived from photographs, then to ever more abstract images based on the human head, first still interpretable, but then moving to patterns having only a slight residual aspect of a biological curve. Then he created digital images, made by hand on the computer, based on geometrical forms. This work involved patterns of superimposed shrinking squares and triangles, strongly colored or in black and white, and led finally to images involving single lines. More recently he has been exploring black and white images and videos.

Gilbert has had forty-four one-person shows. He lives in Cambridge, Massachusetts with his wife, Celia Gilbert, an artist and a poet, who has published five books of poetry.

Wally Gilbert Solo Exhibitions

"Wally Gilbert: A Room of Light," Milton Art Museum, Canton, MA	2013
"Wally Gilbert: New Black and White Images," Viridian Artists, Chelsea, NYC	2013
"Wally Gilbert: New Work," LACDA, Los Angeles, CA	2012
"Wally Gilbert", CJ Gallery, Art San Diego 2012, San Diego, CA	2012
"En-Lighten II," Khaki Gallery, Boston, MA	2012
"En-Lighten I," Khaki Gallery, Boston, MA	2012
"Journeying," The Artemis Gallery, Krakow, Poland, curated by Wieslawa Piotrowska-Sowadska	2012
"Pattern & Recognition," The Art Gallery, Antelope Valley College, Lancaster, CA	2012
"Squares, Triangles, and Lines," Galerie im Einstein, Berlin	2011
"Projekt Norblin," New Art Wet Music Foundation, Bydgoszcz, Poland	2011
"Squares and Triangles," Viridian Artists, Chelsea, NYC	2011
"Geometric Series: Squares and Triangles," LACDA, Los Angeles, CA	2011
"Vanishing," CJ Gallery, San Diego, CA	2010
"Vanishing Profiles," Khaki Gallery, Boston, MA	2010
"The Norblin Project and Other Images," CJ Gallery and OCIO DESIGN GROUP, San Diego, CA	2010
"Wally@Wainwright," Wainwright Bank, Cambridge, MA	2010
"Vanishing," LACDA, Los Angeles, CA	2010
"Vanishing," BAAK Gallery, Cambridge, MA	2009
"Ballet Silhouette Images," Brite Smile, Beverly Hills, CA	2009
Norblin Installation, Poznan, Poland, curated by Jan Kubasiewicz and Zuk Piwkowski	2009
"Boston Ballet & Beyond," Schomburg Gallery, Santa Monica, CA	2009
"Stillness and Motion Images," Brite Smile, Beverly Hills, CA	2009
"The Norblin Project and other Images," CJ Art Gallery, San Diego, CA	2009
"IN COLOR & BEYOND," Khaki Gallery, Boston, MA	2009
"Fresh Fruit," Mayyim Hayyim Gallery, Newton, MA	2009
"Nine Ballet Images," Brite Smile, Beverly Hills, CA	2009
"Stillness and Motion," Audis Husar Fine Art, Beverly Hills, CA	2008
"Stillness and Motion," Viridian Artists, Chelsea, NYC	2008
"LEEKS & CHAINS," Khaki Gallery, Wellesley, MA	2008
"The Norblin Project and other Images," CJ Art Gallery, San Diego, CA	2007
BAAK Gallery, Cambridge, MA	2007
Norblin Installation, Galeria PATIO, Lodz, Poland, curated by Zuk Piwkowski, Jan Kubasiewicz, and Aurelia Mandziuk	2007
Norblin Site Installation, Warsaw, Poland, curated by Jan Kubasiewicz and Zuk Piwkowski	2007
"The Norblin Project: Images of Decay," American Center for Physics, College Park, MD	2007
"IN COLOR," Khaki Gallery, Wellesley, MA	2007
"The Norblin Project: Images of Decay," LACDA, Los Angeles, CA	2006
"The Norblin Project: Images of Decay," Viridian Artists, Chelsea, NYC	2006
Jock Colville Hall, Churchill College, University of Cambridge, Cambridge, UK	2006
BAAK Gallery, Cambridge, MA	2006
Cold Spring Harbor Laboratory, Cold Spring Harbor, NY	2005
Cold Spring Harbor Public Library, Cold Spring Harbor, NY	2005

Ann Janss Gallery, Los Angeles, CA — 2005
SCAT gallery, Somerville, MA — 2005
Doran Gallery, Massachusetts College of Art, Boston, MA, curated by Jan Kubasiewicz — 2004

Joint Exhibitions with Celia Gilbert
"Beans and Bands" Schomburg Gallery, Santa Monica, CA — 2011
"Faces Old and New" Schomburg Gallery, Santa Monica, CA — 2010

Wally Gilbert is represented by:

Amy Delaporte
Art Client Services
1112 Montana Avenue, Suite 800
Santa Monica, California 90403
tel./fax: 310-451-4346
http://www.artclientservices.com

CJ Art Gallery
10755 Scripps Poway Parkway, Suite #542
San Diego, CA 92131
tel. 619.850.7989
email. info@cjartgallery.com

Khaki Gallery
460 Harrison Avenue, Boston, MA 02118
9 Crest Road, Wellesley, MA 02482
tel. 781-237-1095 tel. 781-572-7263

Viridian Artists
548 W 28th Street, sixth floor
New York, NY 10001
tel. 212-414-4040

www.ingramcontent.com/pod-product-compliance
Lightning Source LLC
Chambersburg PA
CBHW050353180526
45159CB00005B/2003